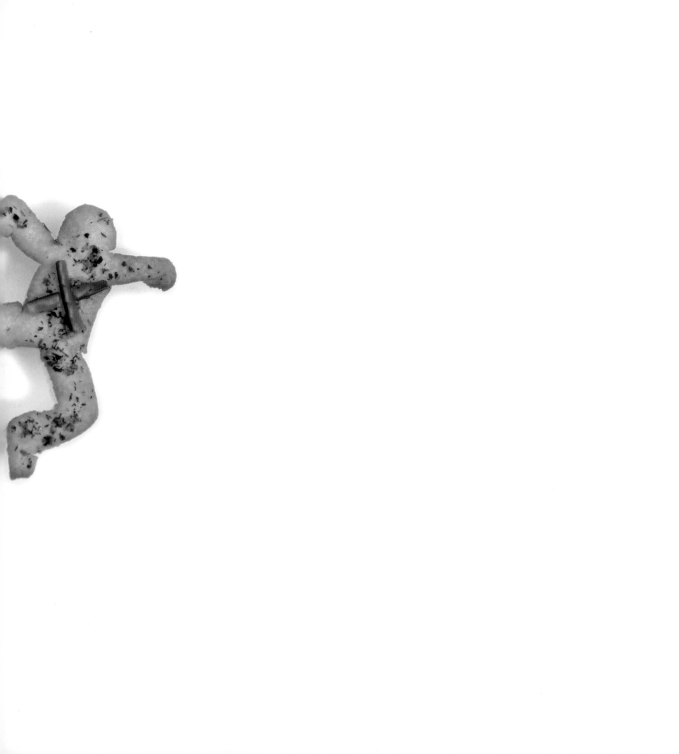

by
KARIN
NIEDER
MEIER

Pizza Art

The most delicious pieces of art
you have ever eaten!

The
Globe
Pequot
Press

GUILFORD, CONNECTICUT

Library of Congress Cataloging-in-
Publication Data is available.

ISBN 0-7627-3064-1

Manufactured in China

First Globe Pequot Edition/First Printing

Contents

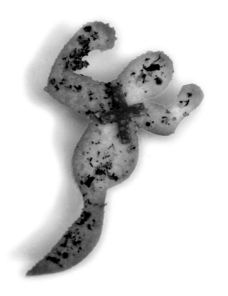

Pizza Art

The History of Pizza

Did you know that pizza has an almost 3,000-year-old history? ◉ Almost all cultures have different forms of flat bread—made out of flour, water, and other ingredients—as an important part of their diet. ◉ In ancient Egypt they celebrated the birthday of the pharaohs with a type of pizza. According to Herodot, the Babylonians had pizza recipes in the seventh century B.C. ◉ Flat breads were the main diet of ancient armies, and the ancient Greeks baked flat breads that resembled pizza. Greek authors even wrote about *maza,* as pizza was called in ancient times. ◉ Pizza probably came to Greece from Italy, where pizza was the typical, local dish of the Mediterranean. In Naples pizza was served with the two ingredients we most think of as essential—tomato and cheese—and the Margherita was born.

There are numerous legends about how the name Margherita came to be. The first tells us about a poor woman called Margherita who did not know how she would feed her family. ◉ In desperation, she kneaded flat bread, put some tomato sauce on it, sprinkled it with cheese, and baked it on hot stones. ◉ The family loved it and named the pizza after their mother. So goes the story of the inventive Mama Margherita.

A second legend leads us back to the times of the Italian monarchy. Raffaelo Eposito, of the pizzeria "Pietro e Basta Cosi," prepared three different types of pizza: ◉ one with olive oil, cheese, and basil; ◉ one with small white fish, the so-called *cecenielle;* and one with mozzarella and tomatoes. ◉ The last one was a favorite of Her Majesty Queen Margherita von Savoia. In July of 1889, her

chef, a Mr. Galli Camillo, supposedly wrote a letter thanking the owner of the pizzeria on the Queen's behalf, and thus it became Margherita's pizza. ◯ Maybe the truth lies in a third version. Or perhaps poor Mama Margherita invented the Pizza Margherita and later on, through a friend of the family, it found its way to the Queen's kitchen. ◯ Whatever the truth may be, it is just important that this basic pizza was invented in the first place! Otherwise we would have no canvas for our artful ones. But let's continue to trace the history of pizza. ◯ From the Middle Ages to the Renaissance, pizza conquered the hearts of both the simple people and the aristocracy. It was the meal of both the common man and the king. ◯ The word *pizza* already appears in the high Middle Ages. In the following centuries, more and more local variations of pizza appeared. It changed constantly from sweet to salty, and today you can find everything from pizza bread to dessert pizza on any Italian menu.

In the 1800s pizza was talked about everywhere, and the Neapolitans' favorite meal became the culinary tradition of the city. Pizza was baked in brick ovens and then sold in the streets and alleyways by loudly shouting errand boys. Already you could "call for a pizza." ◯ At the turn of the century, people began to eat pizza not only on the street or at home but also in the places where they were made, fresh from the brick oven. Bakers placed some tables and chairs in their kitchen and people came to eat and to watch the pizza maker in full action. The "Pizzeria" had arrived.

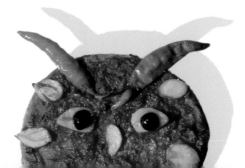

Today in the United States alone there are more than 61,000 pizzerias, most of which offer delivery services.

Over the course of the twentieth century, pizza conquered Europe and the New World—America. Italian immigrants brought pizza to New York City and Chicago, and there some differences developed. ◉ The New York pizza is a lot thinner than the one in Chicago, mainly because a thin crust could be baked a lot faster. However, you could not place as many toppings on such a thin base and thus some pizzas seemed little more than crust. ◉ In Chicago, where the people apparently had more patience, pizza was baked in deep dishes with lots of ingredients. ◉ All across the country, pizza began being served in small street cafes, and everybody from students to American soldiers loved it. It also became increasingly popular in Asia. ◉ In India, flat breads were already a staple in every kitchen.

So around the world, pizza developed in varied types and sizes. ◉ Apples or cherries, spicy sauces or Mexican flavoring, spinach or feta cheese—everything and anything can be put on a pizza. If you heap the ingredients on one half of the pizza, and fold the circle over and then pinch together the edges—voilà! You've created a calzone. ◉ Pizza is a fun food for both adults and children as it is easy to eat with your hands — and to decorate with your favorite extras. So forget knives and forks!

Pizza and Its Ingredients

You already know the basic ingredients of a Pizza Margherita—flour, water, olive oil, tomatoes, and mozzarella. These ingredients can vary depending on the type of pizza we want to bake.

Flour contains complex carbohydrates, which are absorbed more slowly than simple carbohydrates such as sugar. ◉ This is why pizza fills you up and is considered a complete meal.

Olive oil is the healthiest fat and is rich in HDL, the good cholesterol that cleans the arteries. Olive oil also contains the vitamins A, D, E, and K. ◉ I think the best olive oil is the cold pressed one from Crete.

Mozzarella cheese is rich in protein. ◉ Typical spices for a pizza are basil, garlic, and oregano. ◉ Basil smells infatuating, has antiseptic properties, prevents infection, and helps digestion. ◉ In folklore, garlic was thought to be a good agent against vampires. We know it strengthens the heart and that fresh garlic helps to clean the blood. Garlic is especially rich in vitamin C, thiamin, and sodium. Long ago, the builders of the Egyptian pyramids consumed garlic on a daily basis to prevent illnesses. The Greek physician Gaten (circa 130 – 200 A.D.) labeled garlic as the most important of the natural medicines. ◉

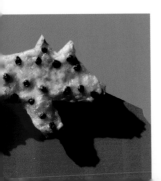

Oregano stimulates the appetite and is good for the throat, as it soothes coughs and curbs infections.

○ It is interesting that all these ingredients, all big parts of the Mediterranean diet, help to fend off the prevalent diseases of our time: calcification of the arteries, high blood pressure, and the risk of heart attack.

Pizza also contains iron and vitamin B. ○ It is easy to digest and does not make you fat (unless, of course, you top your pizza only with lots of cheese).

Hot or Cold?

For lunch or for dinner you serve the pizza hot. The important thing is that the cheese melts and is nice and stringy. ○ You can eat cold pizza for breakfast. It is something you have to get used to but some people swear by it. ○ You can also simply warm it up in the microwave, but don't overheat it or it will become rock-hard. Some people actually prefer the reheated pizza, but in my opinion it tastes best straight out of the oven.

11

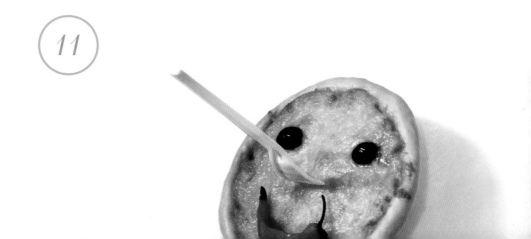

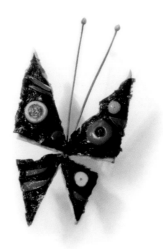

Basic Recipes

Pizza Dough

Ingredients for about 10 minipizzas: ○ 4 cups flour ○ 1 packet dry yeast ○ 1 tablespoon sugar ○ 1 heaping teaspoon salt ○ 6 tablespoons olive oil

Place the flour in a bowl and make a hollow in the middle of it with a spoon. ○ Sprinkle the yeast and the sugar into the hollow. Place 4 tablespoons of lukewarm water and some flour from the edge of the hollow over the yeast and sugar and stir it briefly. Cover the bowl with a cloth and put it in a warm place for about 15 minutes. ○ Add salt, ½ cup lukewarm water, and olive oil to the dough and mix in the rest of the flour. ○ Use a mixer to initially knead the dough, then place it on a floured surface and knead again with your hands until it is smooth. ○ Cover the dough and let it rise for another 30 minutes. Preheat the oven to 350 degrees F. ○ Grease the baking sheets with butter, olive oil, or other vegetable oil. ○ Roll out the dough with a rolling pin on a floured surface to about the thickness of your finger. ○ With a sharp knife cut out the shapes, depending on which work of art you intend to create. Place the pizzas onto the baking sheets, brush on the tomato sauce, and sprinkle it with cheese. Further ingredients depend on the theme of your pizza. ○ Bake the pizzas in the oven for 15 to 20 minutes until crisp.

Tomato Sauce

Ingredients for about 10 minipizzas: 1 small onion ○ 1 garlic clove ○ 2 tablespoons olive oil ○ 14 ounces peeled canned tomatoes ○ sugar ○ salt ○ pepper ○ oregano ○ basil

Peel and finely chop the onion and garlic and lightly sauté them in a small pan with olive oil. ○ Drain the tomatoes in a colander, add to the pan, and crush with a spoon. ○ Season to taste with sugar, salt, pepper, oregano, and basil. ○ Cook on low heat for about 15 minutes.

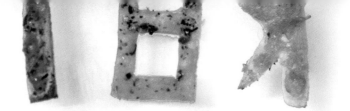

Pizza Bread

Ingredients for about 12 minipizzas: ○ 4 cups flour ○ ½ packet of dry yeast ○ 1 teaspoon sugar ○ 1 heaping teaspoon salt ○ 4 tablespoons olive oil ○ 4 ounces grated Parmesan

Prepare the dough as described on page 13 until after the first 15 minutes of rising. ○ Then add the salt, ½ cup lukewarm water, and olive oil. ○ Knead it at first with the mixer, then knead again with your hands on a floured surface. ○ Add the Parmesan gradually and knead until the dough is smooth. ○ Cover the dough and let it rise for 30 minutes. Preheat the oven to 350 degrees F. ○ Grease the baking sheets with butter, olive oil, or other vegetable oil. ○ With a floured rolling pin, roll out the dough very thin (about ½ inch) on a well-floured surface. ○ Cut out the forms depending on your work of art. ○ Place the pizzas on the prepared baking sheets and, based on the theme, apply red, yellow, or green sauce (see below). ○ Bake for 10 to 15 minutes or until crisp.

Green Sauce

3 garlic cloves ○ 4 tablespoons olive oil ○ sugar ○ salt ○ pepper ○ oregano ○ basil ○ thyme ○ or use already blended Italian seasonings

Peel and finely chop the garlic cloves and place them together with the olive oil into a small bowl. ○ Season to taste with sugar, salt, pepper, oregano, basil, thyme, or Italian seasonings. ○ Before baking, paint the mixture onto the pizza with a brush or a spoon.

14

Yellow Sauce

1 small onion ○ 6 yellow tomatoes ○ 2 tablespoons olive oil ○ sugar ○ salt ○ pepper ○ oregano ○ curry powder

Finely chop the onion and yellow tomatoes. In a small pan, lightly sauté the onion in olive oil. ○ Add the yellow tomatoes, and season to taste with sugar, salt, pepper, oregano, and curry powder. ○ Cook the sauce for about 15 minutes on a low heat. Spoon the sauce onto the pizza dough and bake.

Sweet Pizza

1 package frozen puff pastry (1 pound) ○ half-pound canned apricots ○ 11 ounce raspberries or strawberries, fresh or frozen ○ 2 teaspoons vanilla extract ○ 2 tablespoons sugar ○ 1 orange ○ 1 lemon ○ 1 egg yolk ○ 2 teaspoons milk

Briefly defrost the puff pastry sheets as directed on the package. ○ For a sweet yellow sauce, drain the apricots and place them in a deep bowl. Grate the orange rind and squeeze the juice into a bowl. Mix the apricots with the orange rind, orange juice, vanilla extract, and sugar. For a sweet red sauce, grate the lemon rind and squeeze the juice into a deep bowl. Add the raspberries or strawberries, vanilla extract, and sugar, and mix. ○ Grease the baking sheet with butter, olive oil, or other vegetable oil. Roll the puff pastry (not too thin!) on a lightly floured surface. ○ Cut out the desired forms with a sharp knife and place them onto the prepared baking sheet. ○ Mix the egg yolk and milk and brush onto the forms. ○ Apply your sweet sauces and other ingredients, depending on the theme of your pizza. ○ Bake in the oven following the directions on the puff pastry package.

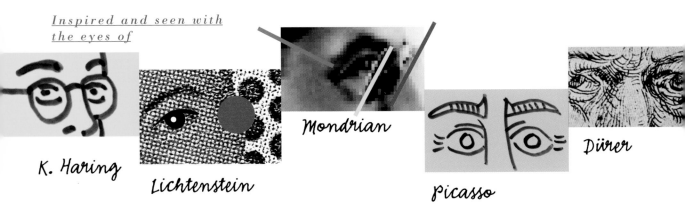

Inspired and seen with the eyes of

K. Haring

Lichtenstein

Mondrian

Picasso

Dürer

The Artists

Bread a la Picasso

Pizza bread is good for all occasions, not only as an appetizer for Italian meals but also as a snack. • You can make this when you have time and can enjoy creating a fun snack in visually pleasing forms. • Our inspiration here is the Master Pablo Picasso. His simple, linear, and expressive drawings can easily be transferred onto pizza dough. Roll out the dough thinly and cut out the desired forms with a sharp knife. • The details can be easily added by pressing extra ingredients into the soft dough with the back of a spoon. • Before baking, brush the dough with olive oil and sprinkle it with garlic powder, salt, and grated Parmesan cheese. The owl is sprinkled with caraway seeds instead of garlic.

Three of Pablo's Eight Silhouettes, 1946.
• *These free spirits will be a hit at your next party!*

For this pizza we took inspiration from Owl with Chair, Pablo's lithograph of 1947. • The eyes are two olives, the beak a marinated garlic clove.

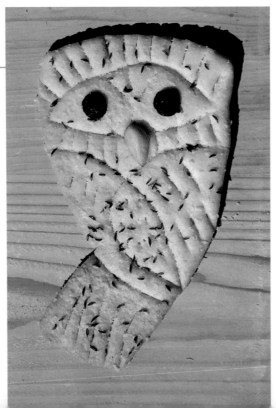

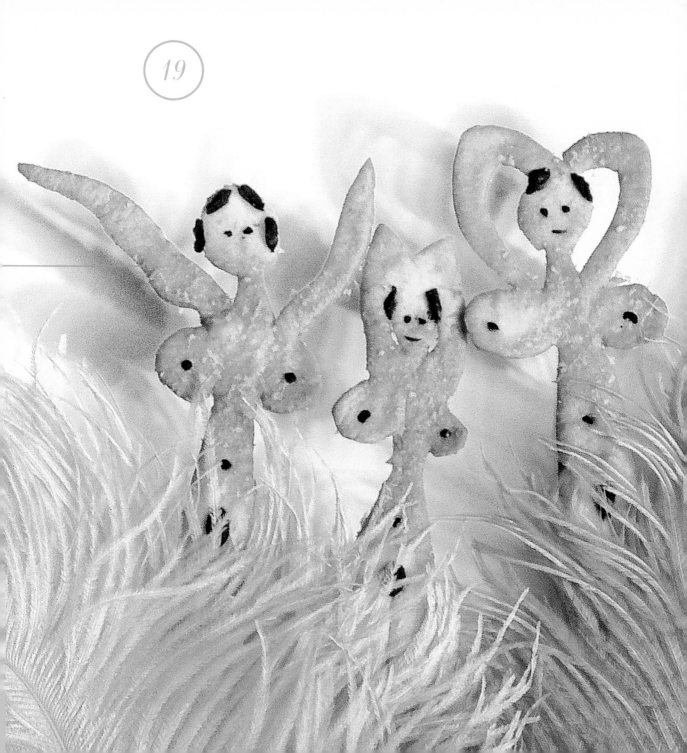

P I Z Z A

a la Picasso

Pablo's *Musical Faun* (1948) reveals his mischievous nature. •
A lot of tomato, sliced garlic cloves, and spicy chili peppers
makes this full-bodied and spicy.

Homage to Magritte

Bring spring to your palate and plate. • Rene Magritte delivered the season with his picture *Spring* (1965). • Sprinkle with plenty of cheese, oregano, and basil, then bake. • After baking, decorate with fresh herbs, such as thyme, and serve immediately, before the dove flies away!

21

PIZZA
a la Mondrian

With Mondrian you can't go wrong. Our model: *Composition in Color A* (1917). • Naturally we had to change the colors slightly because there are no blue peppers! • Cut the colored rectangles from large peppers so that the squares lie flat. • The black lines are made with dried seaweed, available in Asian food markets or health food stores. • A truly new creation, this is not only exotic but also very tasty. A real classic.

Pizza a la Mondrian is well suited for your pizza party. • Fill a whole baking sheet, cut it in small pieces, and all your guests can have their own mini masterpiece.

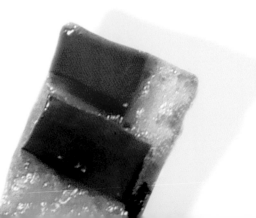

22

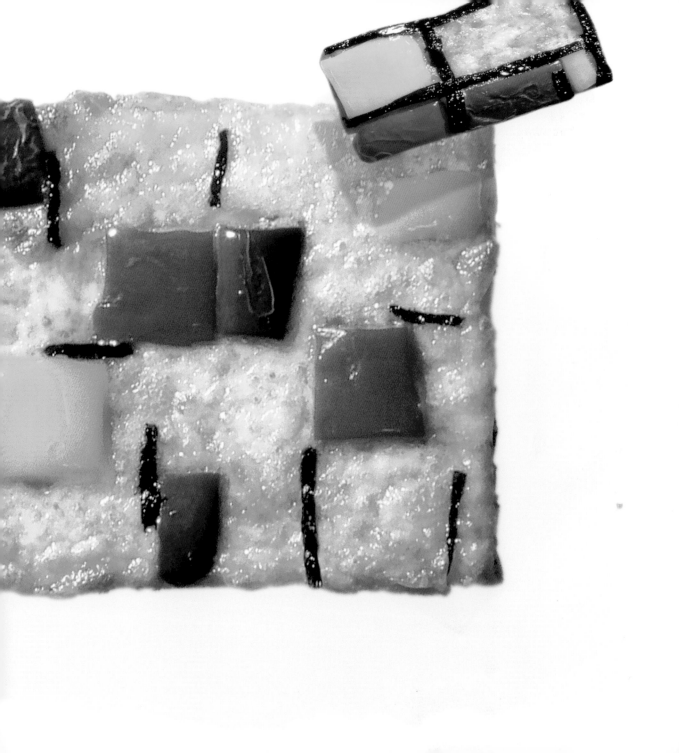

Abstract Space

Line play with Mondrian. • Your friends will be astonished; they will have never seen a pizza like this before! • Line compositions are exactly the right thing for discriminating guests. Whoever can guess which compositions are based on the master's actual models can get an extra slice. • Here we have pizza modeled on *Composition with Two Lines* (1931), *Composition II with Black Lines* (1930), and *Composition with Yellow Lines* (1933).

Cut the seaweed with scissors like paper, making sure to cut the strips about half an inch longer than you think you'll need, as they will shrink in the heat. • Hint: It tastes best if you put the strips onto the hot pizza after baking. •

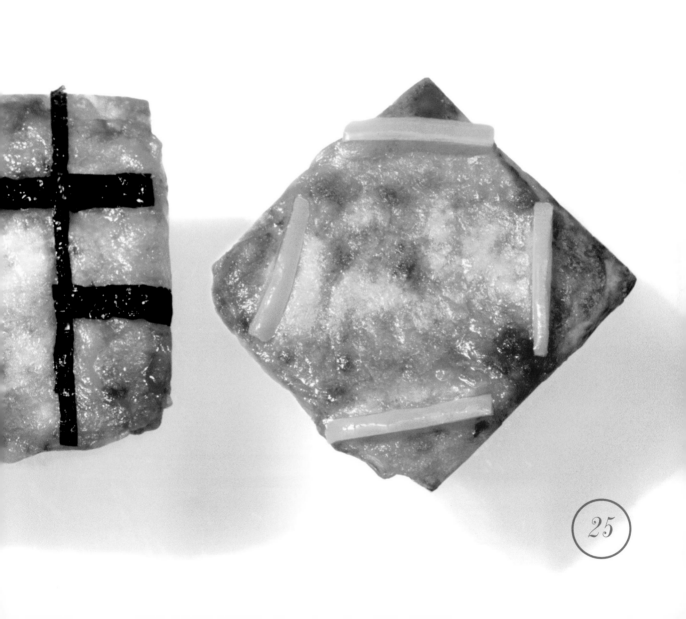

a la Lichtenstein

Play golf with Lichtenstein! • The perfect pizza for fans on and off the green. • To make the half-circle dimples, take a long and narrow pepper, cut it in half lengthwise, and then cut it into strips. Place on top of the sauce and cheese and bake. • Our model: *Golf Ball* (1962).

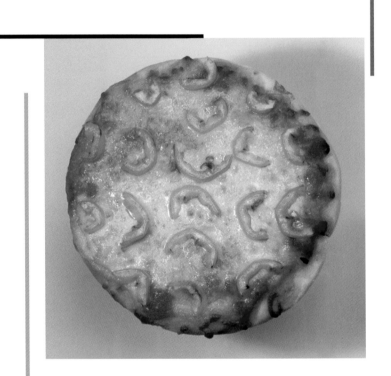

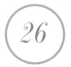

PIZZA
Red Sock

Bake socks with Lichtenstein. • Roy Lichtenstein, one of the founding fathers of Pop Art, probably never dreamt that his ideas would be translated into pizza design. • Today this pizza, modeled on the artist's *Sock* (1961), is a must-have menu item for all Red Sox fans. • Cover with plenty of tomato sauce and decorate with seaweed strips after baking.

If you wish to make "Hot Socks," mix the tomato sauce with hot pepper flakes.

•

No eye will stay dry.

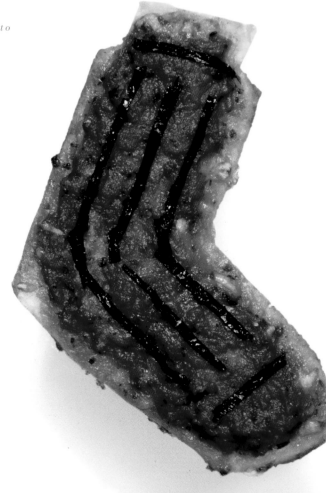

P I Z Z A
Sunrise

. . . and the sun always rises. • *Sunrise* (1965) by Lichtenstein.
• Pizza for breakfast? If that is too radical for you, then think
of this as the sunset, and enjoy your pizza for dinner. • The
hills and the sun and its rays are made from yellow peppers;
capers and green and red pepper strips add the details.

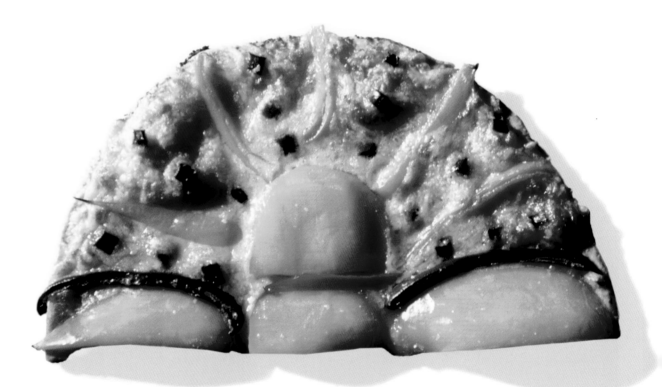

For a delicious
variation
use
canned peach
slices.

PIZZA
a la Milton Glaser

Isn't it wonderful, retro, and tasty to have a record as a pizza? • Beneath the black seaweed lies tomato sauce topped generously with grated cheese. In the middle we placed a slice of eggplant (in Asian stores you can find them in blue, yellow, and white), yellow pepper, and zucchini. • A caper marks the hole in the record. Off with the pizza into the oven. (The seaweed is put on after baking, but you already know that.) • Our model: *Utopia Records* (1975).

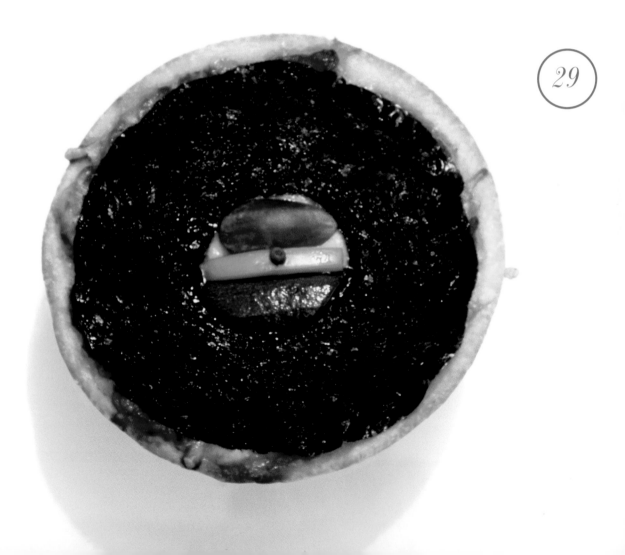

P I Z Z A
Tanaka's Butterfly

This striking butterfly brings Japanese aesthetic to your pizza. • The form derives from the <u>Japanese grandmaster of graphic design,</u> Ikko Tanaka. • You define the taste with seaweed, eggplant, olives, colorful peppers, cherry tomatoes, or chilies. The two antennas of the butterfly are made of chives that still have their buds. • Our model: a poster for Hanae Mori by Ikko Tanaka (1978).

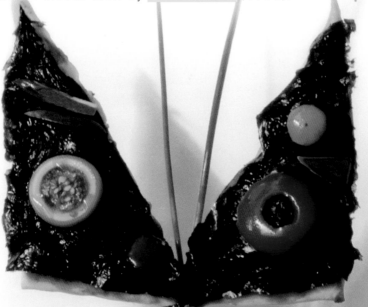

Tip:

To create this pizza, cut two rectangles from the pizza dough, one larger and one smaller. • Then slice these diagonally in half and arrange to create the form of the butterfly.

PIZZA
a la Jasper Johns

Painter Jasper Johns reduced the formal content of his pictures to a few patterned elements. • That makes it easy for us to translate his work onto a pizza. Let the lines dance! • The pepper strips are the men and the zucchini strips are the women. • Our inspiration: *Dancers on a Plane* (1979), exhibited as part of a multimedia show with composer John Cage and dancer-choreographer Merce Cunningham.

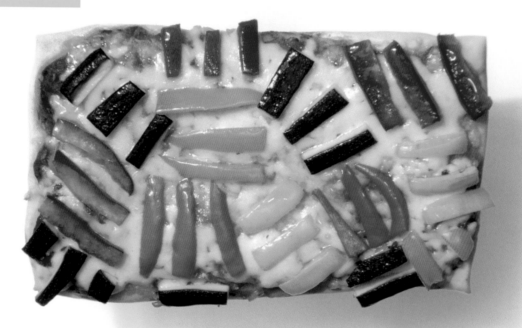

31

I'd love to dance across a stage of mozzarella!

Sculptural Shapiro

Our model: *Untitled* (1995–1997) • Joel Shapiro did not name his sculpture, so you can interpret it as you wish. • How about this? <u>Stick Man</u> at the City Marathon. Just as he is about to cross the finish line, he trips! • But don't take as long as Shapiro did to finish your pizza creation, or it will be inedible. • We covered our pieces with extra cheese, cherry tomatoes, and seaweed.

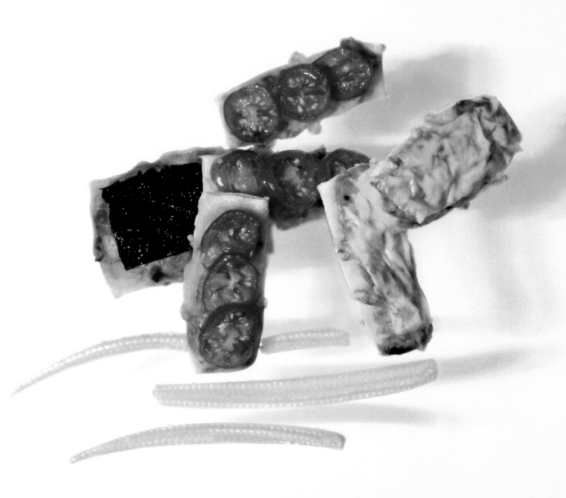

Homage to Frank Stella

Frank Stella lets the relationships dance. • His elongated <u>triangles</u> split apart and pull together at the same time. • Because pizzas taste best when they are hot, we took our inspiration from Stella's Brazilian Series, which are <u>colorful and exotic.</u> • Our model, *Arpoador* (1974–1975), is fine and spicy and has Brazilian temperament.

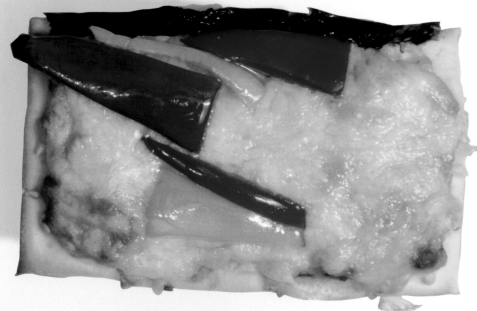

a la Vasarély

The usual picture themes and content are missing in the work of Hungarian/French abstract painter Victor Vasarély. • The meaning of his pop art is solely visual. • This artist wants to consciously inspire us to see shapes and surfaces as interactive and kinetic through his preferred manner of design, a grid.

34

With slices of stuffed olives and capers you can imitate the most beautiful of Vasarely's designs. Or you can use black olives and colorful pieces of peppers as in the picture below. • Visually interesting variations can be achieved with cherry tomatoes, cherries, or anything else that is round and tastes good. • Let your fantasies run wild and intrigue your guest with optical and spatial illusions a la Vasarély.

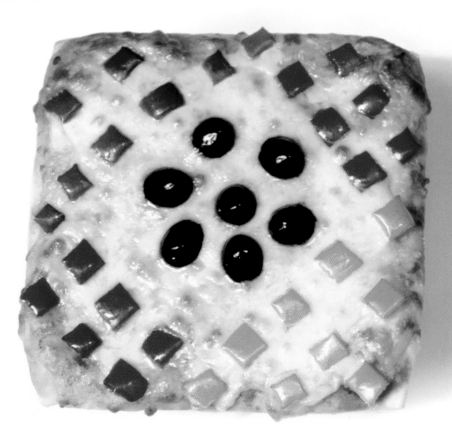

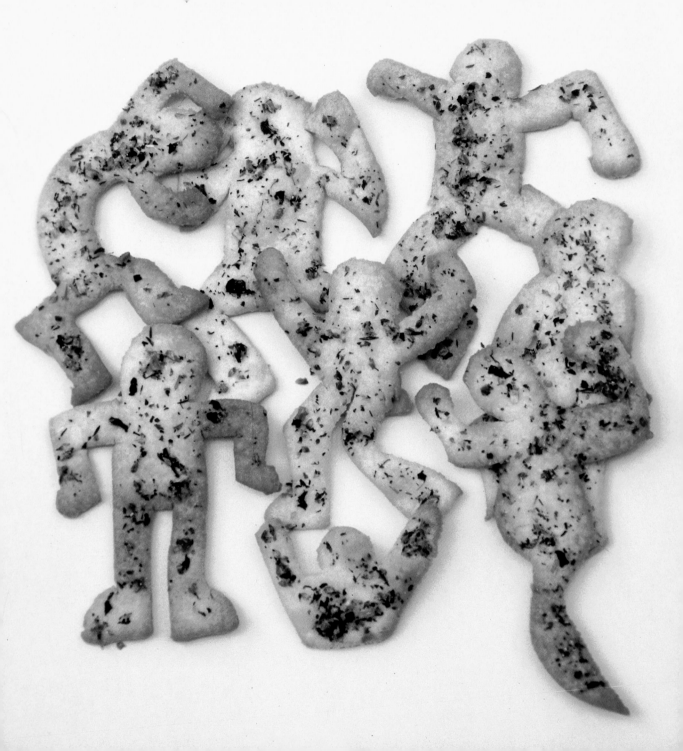

Homage to Keith Haring

You could fill a whole book with crazy pizzas based on Keith Haring's ideas. Haring loved to draw as a child and kept expressing himself—both in art school and in graffiti in the New York City subway stations. • Although he died young, his imagination lives on. • Haring's little figures make ideal pizzas. • Whether they are offered mixed and interacting or served solo, you will always have a great piece of art and a fun plate of pizza!

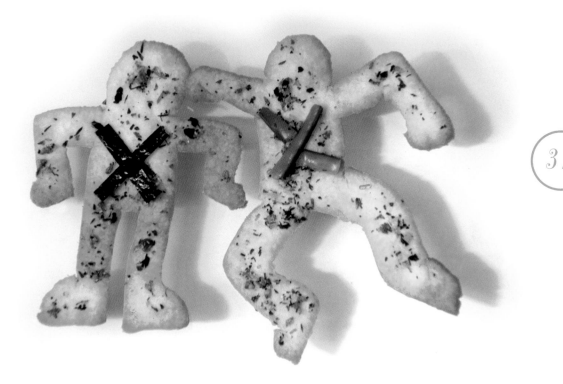

37

*Copy these patterns
onto wax paper to help
you easily cut out the
forms in your pizza
dough. • Or be creative
and give each of your
figures a special and
individual look. • It is
fun and easy.*

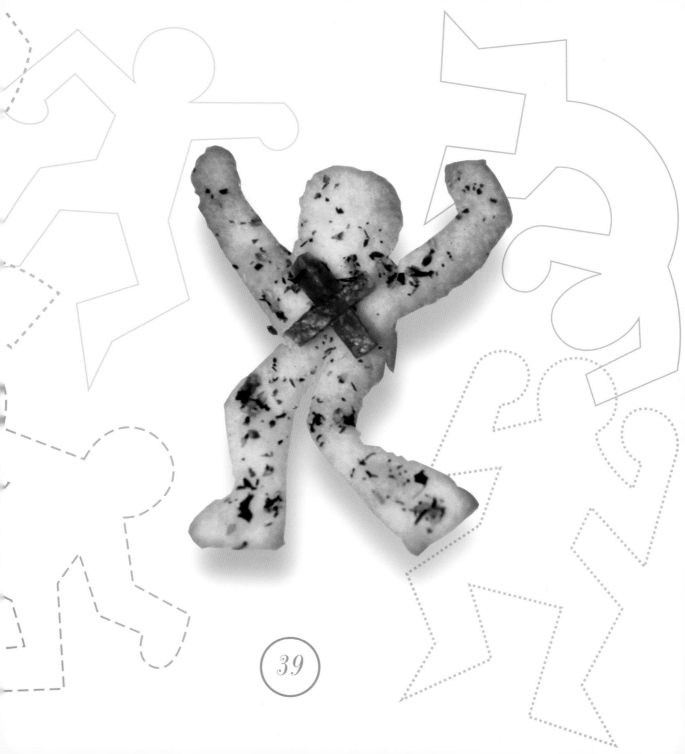

Bow-wow!

Is this what you think of when you say "dog food"? • Have
a bite—this puppy tastes great and is also perfect for
sharing with your special (spoiled) pooch. • The funny
pattern on the dog is made with capers. If you want it a bit
spicier, you can use marinated peppercorns. • Be sure to
make enough for a doggy bag!

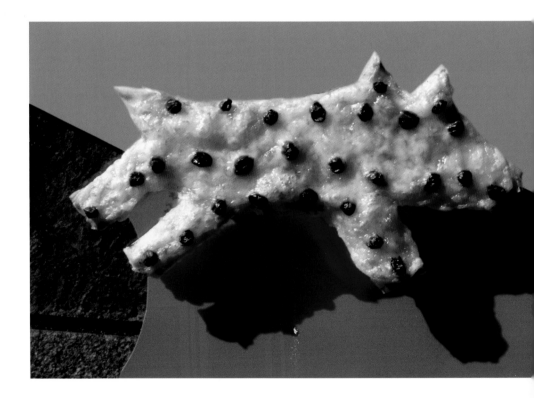

Red Face

Our little man is waiting to be dressed. Help save him from embarrassment by adding some clothes—perhaps of broccoli or green pepper. Or decorate as you would a gingerbread man, with olives for buttons and onions for trim.

Albrecht Dürer

This old German master is open to modern culinary interpretation. • Here Adam and Eve play with cherry tomatoes instead of apples. • Bake them as you would a real pizza, so that they rise nicely and become just right to bite into. • For good taste, put a sprig of mint in just the right place. • Our Model: *Adam and Eve* (1507) by Albrecht Dürer.

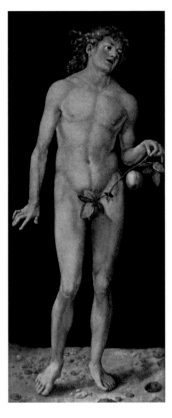
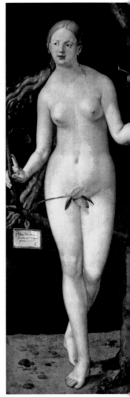

The right appetizer for your biblical pair is a bunny made out of pizza bread. • Our model: Dürer's Young Hare (1502). • Pieces of black olive are used to make the face and paws.

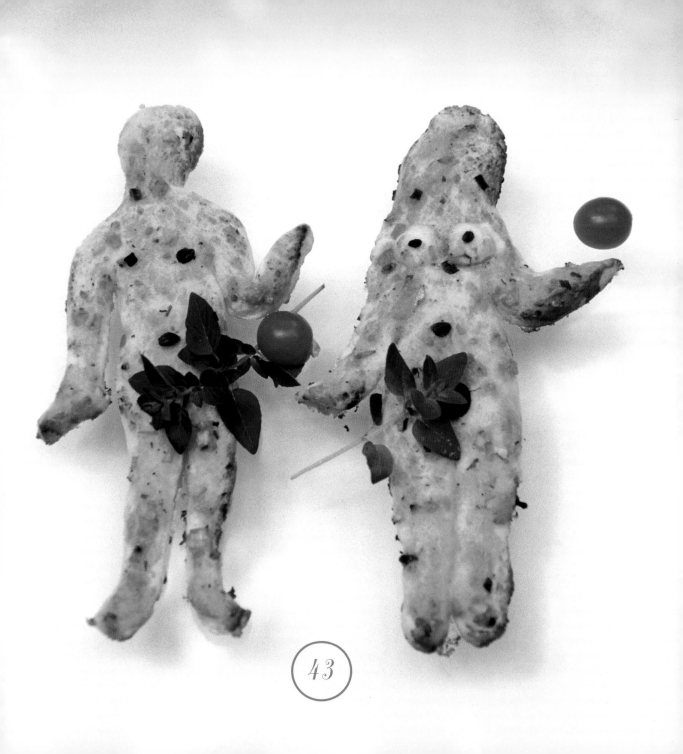

43

Homage to Hokusai

You don't need to start with all of Hokusai's one hundred views of beautiful Mount Fuji. Just begin with one. • What about Mount Fuji behind the bamboo forest? • Here you can be very exotic, using Asian herbs and spices. Or you can make a good German pizza using chives, parsley, and sweet pepper, or make an Italian one with basil and oregano, or even one from the farm with asparagus and green beans.

44

For the very brave chef, pizza created in the style of the master of the Ukiyo-e, or "pictures of the floating world" school of printmaking.

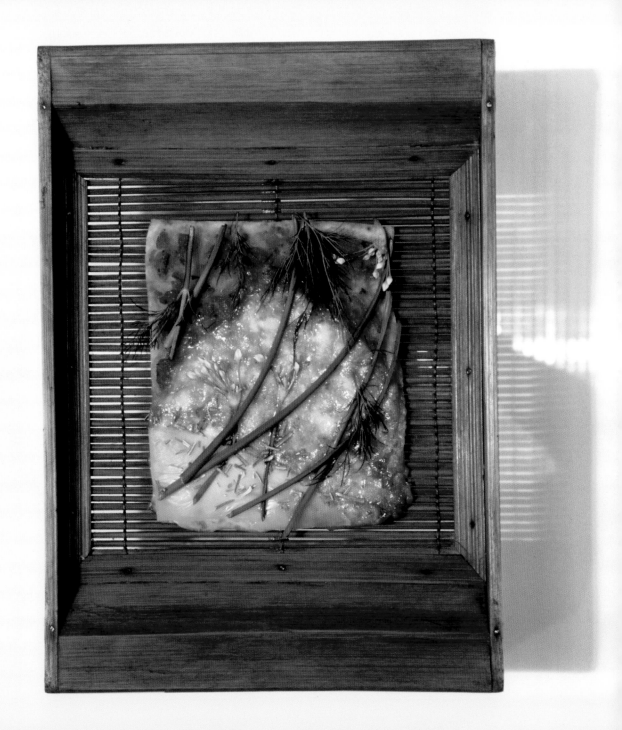

Rousseau's Garden

Let us be inspired by Henri Rousseau's exotic pictures of flowers, his dreamlike poetry, and his pictures of magical gardens. • For the Rousseau pizza, make the basic recipe for Pizza Margherita using either red or yellow tomato sauce and bake it until crisp. Then arrange the fresh toppings on the finished pizza. • These can include: steamed baby corn, green beans, basil, Thai dokkae blossoms, blooming garlic sprigs, peppercorns, asparagus, cherry tomatoes, and whatever else you can find in your herb garden.

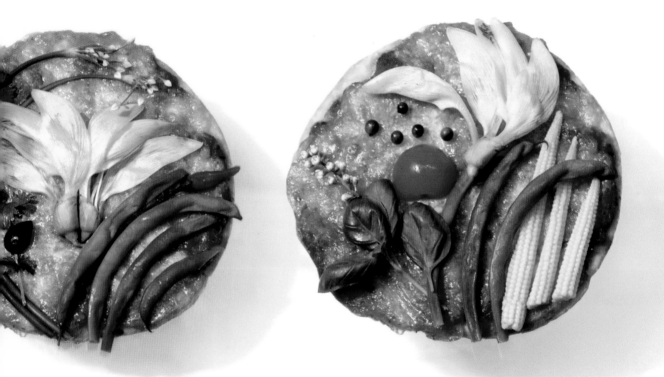

Garden in a different way. • A garden you can eat as you enjoy the wonder of nature.

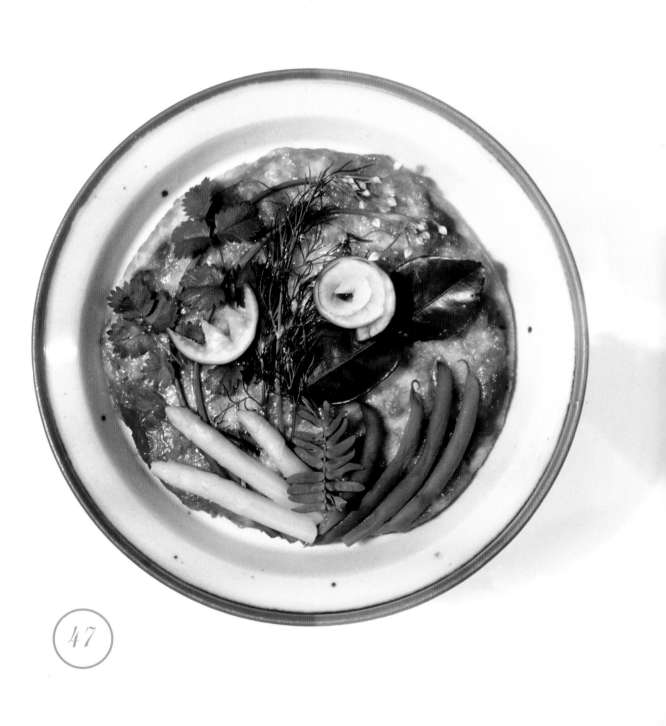

P I Z Z A
a la Kandinsky

Abstract artist Vasily Kandinsky was also an accomplished musician. • He likened the soul to the piano with many strings, color to the keyboard, and the artist to the pianist. • In this way, his lively and colorful variations can make playful pizzas. • Let your own creativity run wild and experience his genius. • Our model: *Various Actions* (1941).

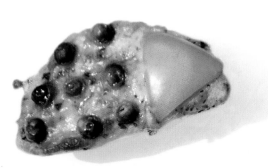

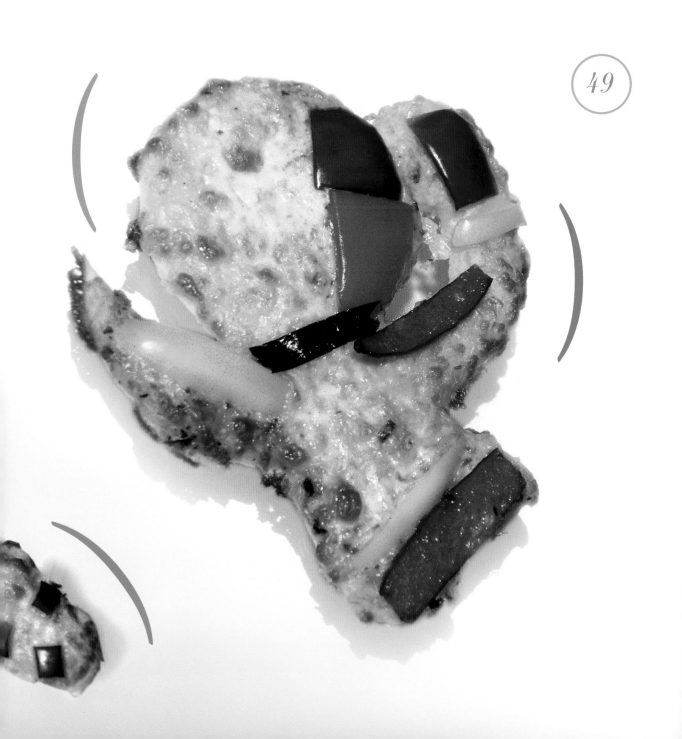

Incan

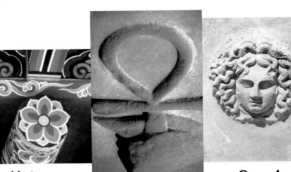

Korean

Egyptian

Greek

Here's challenge of a special kind—to translate the most important periods of art onto your small pizzas. It will be an educational excursion into the history of art, as well as a lot of fun. Examples for your epoch-making pizzas can be found in art history books, museums, and guidebooks. Open your eyes and start your pizza dough!

Art through the Ages

Incan

Let's start with one of the world's oldest cultures. • Incan motifs from textiles and stone reliefs provide endless options for our pizzas. • Their strongly stylized and expressive patterns and symbols for supernatural forces can be easily copied. • Our model: a stylized face from a kilim textile in the Ethnological Museum, Munich.

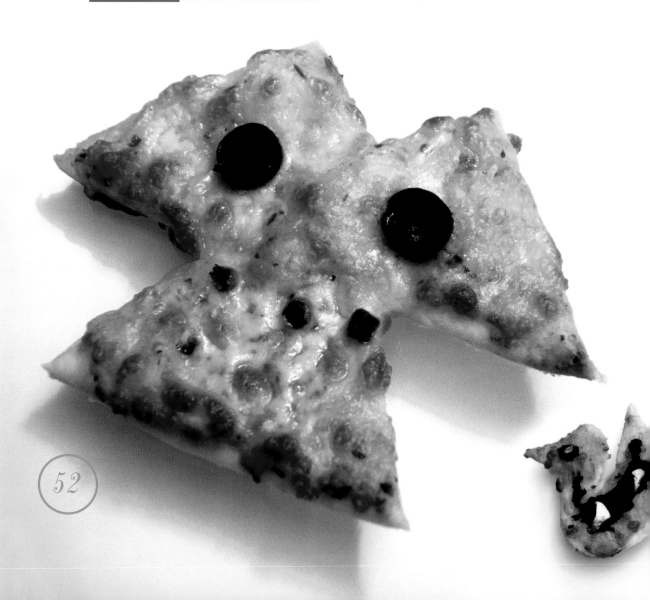

52

Egyptian

We know that Ramses supposedly liked to eat pizza. • But how the ancient Egyptians used the Eye of Horus or other hieroglyphs remains an unsolved mystery. • What matters to us, however, is that it looks and tastes good!

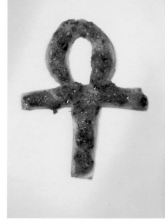

Ankh—the Egyptian key of life—will add something mystical to your pizza party. • You can either stack the keys or hang them like a garland. That way everyone can pick a key of life.

Use eggplant or seaweed strips to make the black stripes on the little Incan birds.

Korean

Korean art has as much significance as that of its great neighbor, China. • Here the stylized flower motif is taken from the roofs of Buddhist temples. • The yellow sauce for this pizza should be spicy, since Koreans like intense seasoning.

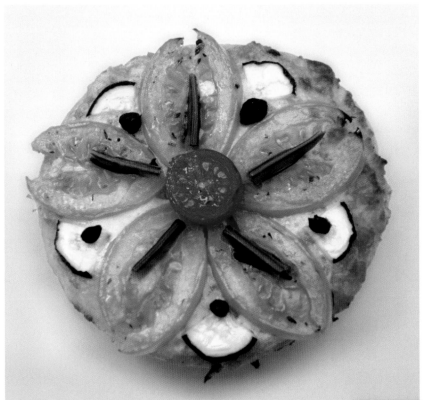

Thanks to Buddha.• Place the paradise flowers found on temples on your pizza. • Use yellow and red tomatoes, zucchini, green beans, and capers.

Greek

The Greeks knew about life and pizza as well as wine, women, and song. • Bring this love of life to your pizza, and snack with delight on the beauties of antiquity. • Motifs such as our happy woman can be found on Greek vases. • Indentations are easily made by pressing the back of a knife, spoon, or fork in the dough before baking.

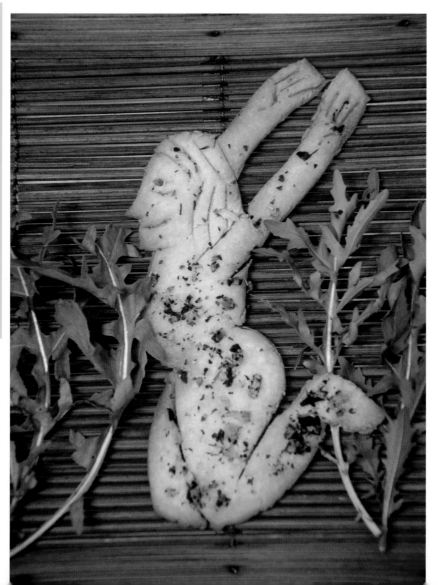

55

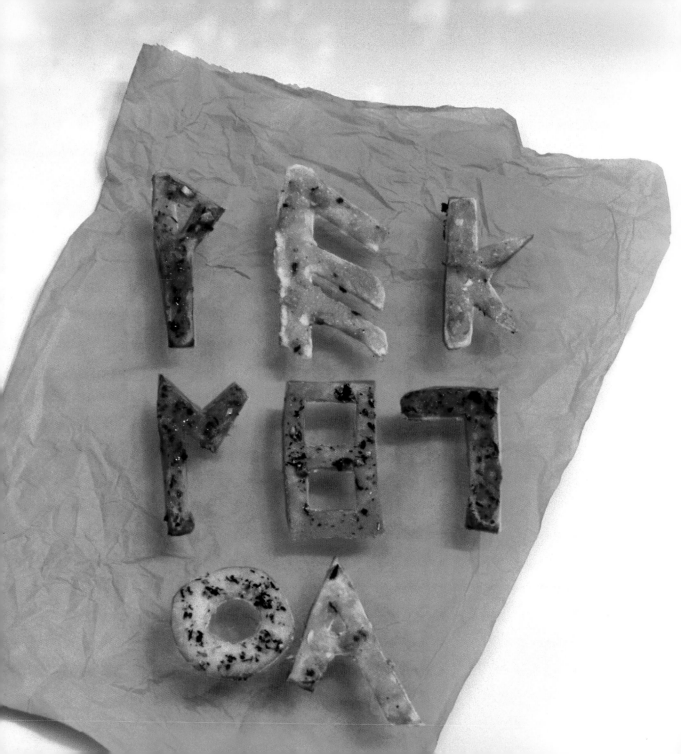

Crispy Runes

Eat like the old Vikings and Germans. • The pizza runes can be served with a `barbecue` or just with beer instead of chips. • Since the runes build an alphabet, you can write complete words with runes. • It's a <u>great</u> party game.

ᚺᚪᛈᛈᛉ ᛒᛁᚱᛏᚺᛞᚪᛉ

h a p p y b i r t h d a y

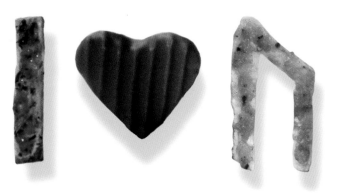

A great party game! With your crispy runes you can send secret messages: I love you, happy birthday, or whatever you want. • *Instead of the runes, you can also use any of the other alphabets of the world. How about Greek, Russian, or Chinese?* • *Now start composing your pizza sonnets!*

ᚠ ᛒ ᛉ ᛗ ᛘ ᚥ ᚷ ᚺ ᛁ
a b d e f g h i

ᛋ ᚲ ᛚ ᛗ ᚾ ◇ ᚷ ᚱ ᚱ
j k l m n o p r

ᛋ ᛏ ᚢ ᛊ ᚥ ᛈ ᛉ ᛉ
s t u v w y z

Art Nouveau

At the close of the nineteenth century, artists across Europe wanted to erase the distinction between the "major" and the "minor" arts, bringing all details of architecture and jewelry into the artistic realm. • Whether your inspiration comes from art nouveau facades on buildings or the fruit of the sea is up to you. • Whatever you choose, you will make an impression with your work of art.

Dada

Not even the Dadaists know what Dada really means. • Who created this word and when and where is no longer known, nor important. • Dada defies definition yet remains the embodiment of modernity with a splash of wit and absurdity. • So when you create a Dada pizza, everything is allowed, from scampi to gummy bears, caviar to a lone pea.

It is clear that these two pizzas require special toppings, such as succulent shrimp, baby squid, and crabmeat. • Using garlic oil on your pizza gives it a special shine and taste.

59

Papa

Mama

You

Me

Pizza Art 101

PIZZA, Artist's Palette

Now it is your turn! • After looking at all those great artists, you should feel inspired to create your own designer pizza. • The palette is ready!

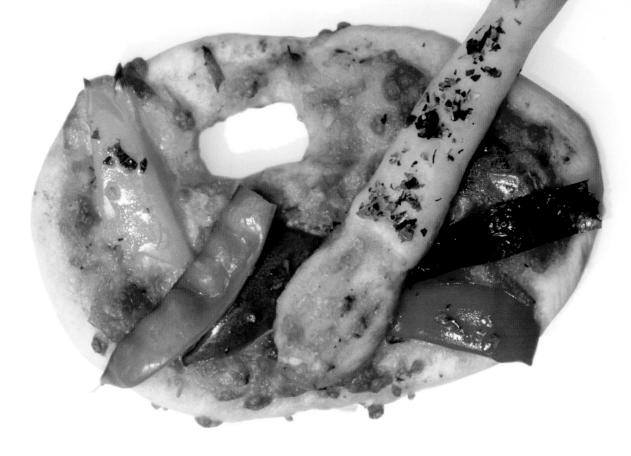

*If you want, depending on the season,
you can also place white blossoms on
top of your pizza after baking. • Try
using daisies, or do as we do and add
dokkae leaves from an Asian shop.*

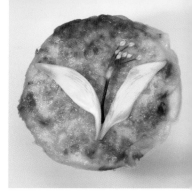

63

P I Z Z A
White

A great party idea: Bake small pizzas in a variety of colors. • Soon you will have a whole table full of tasty colored dots. • Here we have a white pizza. So easy to make! Just sprinkle a lot of mozzarella on top and you are finished.

P I Z Z A
Yellow

The Yellow One. • Do <u>you already know about</u> yellow
tomatoes? You really have to taste them! • Add yellow
eggplants and a thick slice of cheddar cheese to get this
interesting mixture.

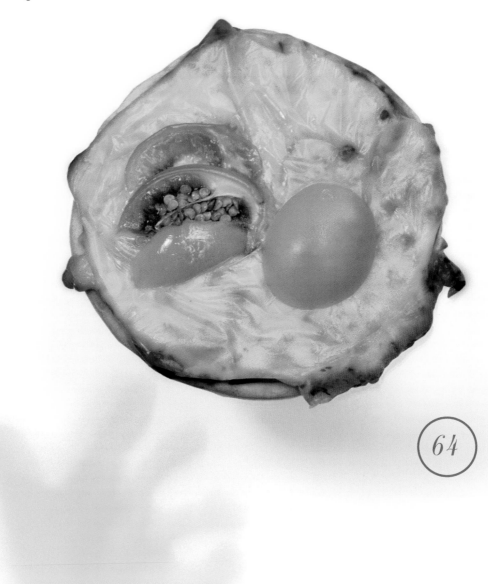

64

P I Z Z A
Red

The Red One. • Needless to say, it is now the red tomatoes'
turn. • Add extra tomatoes after making the usual tomato
cheese variation. • For a special tingle in your mouth,
sneak in some red pepper flakes.

P I Z Z A
Green

The Green One. • Totally natural, made with zucchini cut into thin strips. • Brush with oil and finely chopped garlic, so that your pizza has the right spicy flavor. • Place fresh basil on top just before serving.

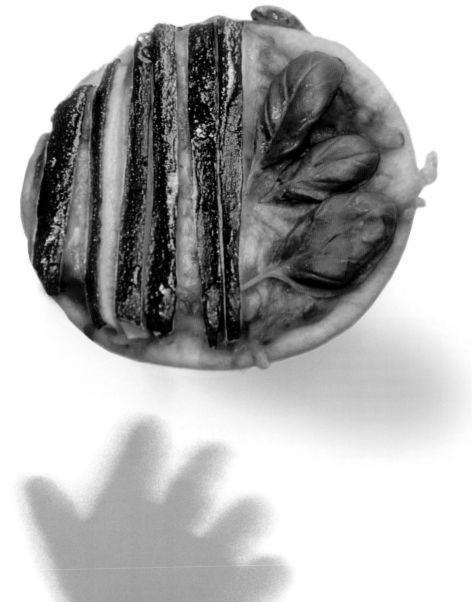

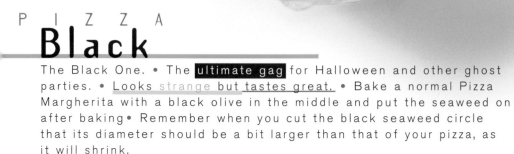

P I Z Z A
Black

The Black One. • The ultimate gag for Halloween and other ghost
parties. • Looks strange but tastes great. • Bake a normal Pizza
Margherita with a black olive in the middle and put the seaweed on
after baking• Remember when you cut the black seaweed circle
that its diameter should be a bit larger than that of your pizza, as
it will shrink.

Sweetie Pie

The Sweet One. • The right thing if you have a sweet tooth or are a honey bee. •
These sweet pizzas are great fun. • You can create wonderful designs on the red
or yellow fruit sauce with fruit gummies, edible flowers, or fresh herbs like mint. •
The Sweet Pizza recipe is on page 15.

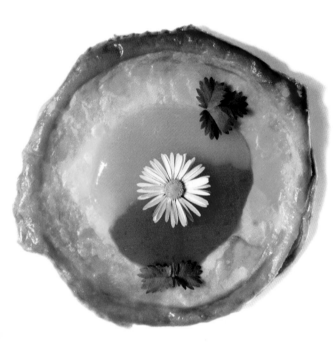

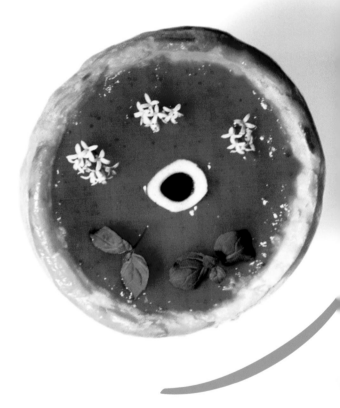

*Sweet pizzas are
perfect for a gathering
of good friends.*

_You can create many
different patterns by cutting
the fruit gummies into strips
or slices • Truffles,
chocolate-covered coffee beans,
or grated chocolate
are all perfect to use on your
dessert pizzas._

Tip:

_With a small bowl as a guide, cut out
the round circles from the slightly
rolled out dough. • To make an
indentation in the dough for the sauce
and to let the edge of your pizza rise,
place a small heat resistant form, such
as a soufflé bowl, on top of the pizza
while it is baking._

For your most beloved pizza
fan. • Love can be so
beautiful. • Cut a little
wedge out of the top of a
strawberry half
to create a heart.
• Use pine nuts to let your
heart glow.

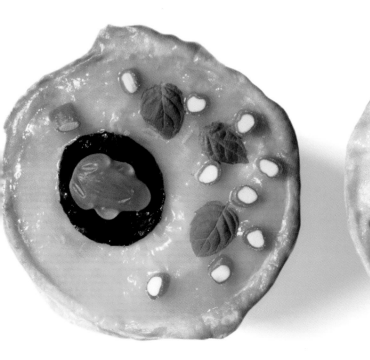

The frog prince awaits! • Place your
gummy frog on a chocolate disc and float
him in a pond of apricot jam. • The
flowers are slices of fruit gummies and
the leaves are mint.

Use cookie cutters to cut out hearts,
stars, or whatever you want from your
puff pastry and bake them alongside
your pizza. • After baking, place these
forms on top of the fruit sauce.

Sweetheart

For your little sweethearts, the pizza that wins smiles from children large and small. • Draw a heart on a piece of baking paper and use it as a pattern for cutting the pastry.

Don't forget! •
As mentioned on page 69,
before baking place a fire resistant
form in the middle of your pizza to
create an indentation.

PIZZA
Star

A star for your little star. • Or you could be nice and bake a star for every one of your dinner guests. • Top it with a strawberry heart, small edible leaves, and edible yellow flower petals, such as marigolds.

Star light
Star bright
First star
I eat tonight!

THE
Pizza Bytes

The pizza for Generation @. • Extremely futuristic for
parties. • Extremely easy to make. • Cover a baking sheet
with dough, spread tomato sauce and cheese over it, and
top with small squares of whatever you can find in your
refrigerator. • After baking, cut into bite-size pieces so
that you don't need silverware.

(74)

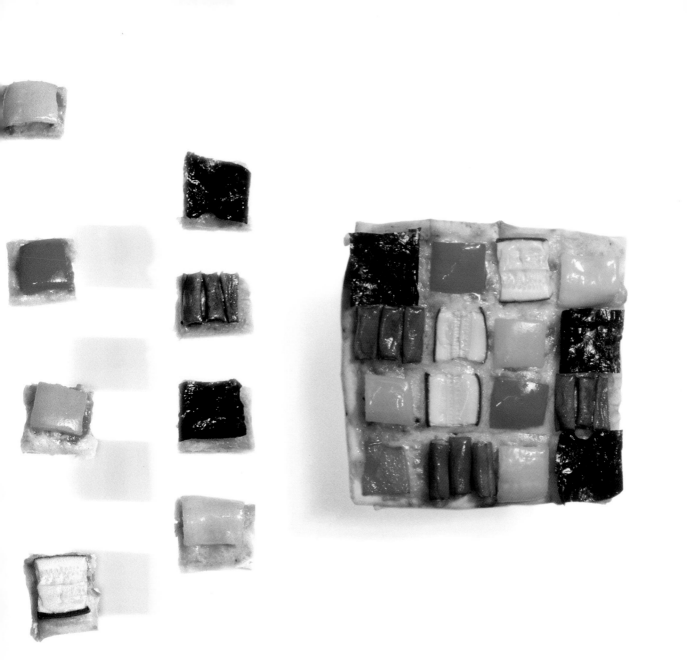

You know the scene: as soon as intermission comes, everyone heads to the lobby in search of a snack. • So unnecessary. • Watch the posh crowd turn green with envy as you, with cool elegance, pull your fancy pizza from your evening bag!

*Of course you take a
heart pizza to Romeo
and Juliet. • For
Percival you can make
yourself a pizza sword.
• For Aida you take
ankh, the key of life
(see page 53).
• Be courageous, and
please send me a photo
of your experience!*

PIZZA
Alien

Make a face! • When you look to space, everything is possible, from a smiley face to an alien monster, with toppings from green beans to hot chilies.

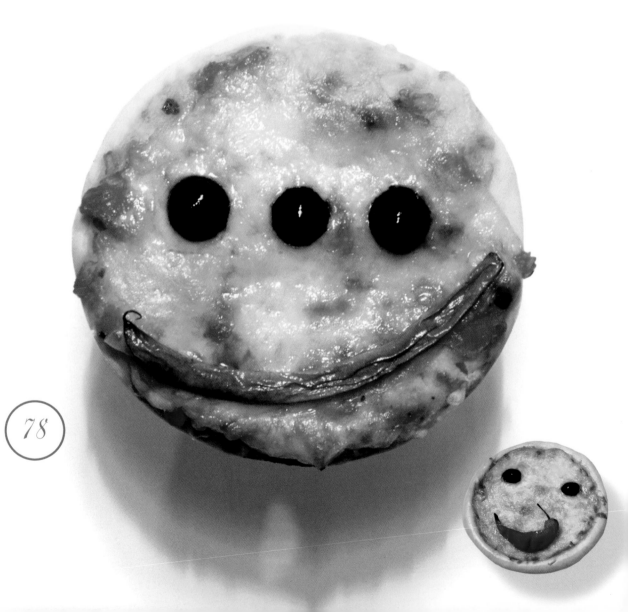

P I Z Z A
Crazy Face

When you don't want to eat alone, create a companion. •
The eyes are battered-fried octopus rings. The eyebrows
and lips are strips of zucchini and the fresh tongue is a
piece of pepper. • Eat up!

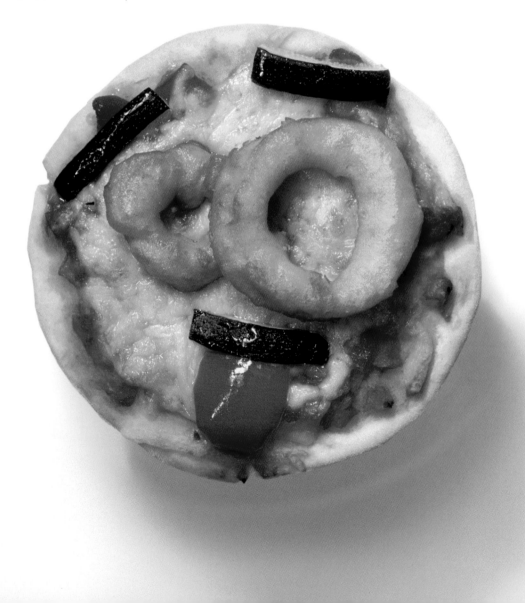

P I Z Z A
Moon

You can choose your favorite planet for this pizza: perhaps the Moon,
Mars, or Venus? • After baking, make the asteroid craters by placing
deep-fried squid or onion rings onto the pizza. • You can also use black
olives, capers, or marinated green peppercorns for your planet's features.

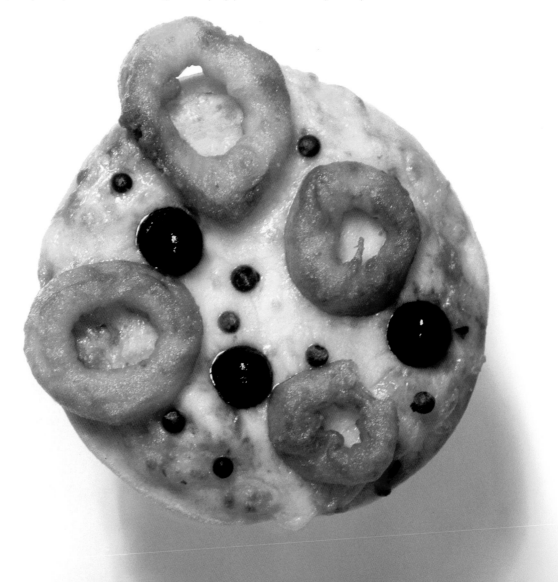

Funny Face

Doesn't our pizza look sad? But you wouldn't look <u>any happier</u> if you were about to be swallowed, either. • Make this funny face with either squid or onion rings. It depends on how you feel.

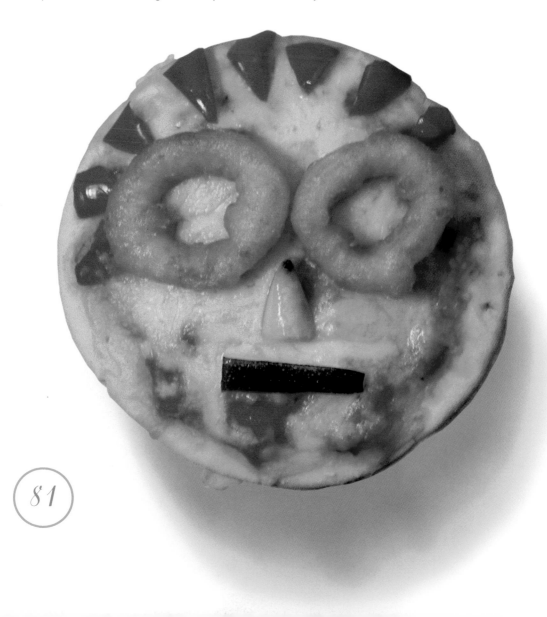

81

Portrait

Just the right pizza for those occasions when you want to tell someone—discreetly— how great he or she is. • Make their likeness on a pizza using only that person's favorite foods.

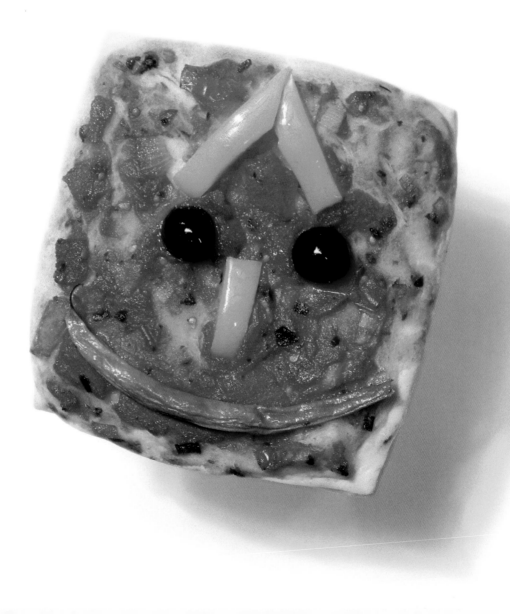

Mr. Cool

This is the pizza for totally
<u>cool types</u>—those who
never get uptight. It's
perfect for the hip
teen or groovy
grade-schooler.

*Take your cue
from ASCII art
or just use your
imagination.*

and elsewh

North

South

East

West

Pizza Art for Children

PIZZA
on a Stick

A new interpretation of a calzone. • In a pan, fry a chicken leg in a bit of oil until it is very crisp. You can either simply use salt and pepper or season it with paprika. • Roll the dough out (not too thin) and cut a circle. Spread tomato sauce over it, leaving a two-finger border around the edge to allow you to pinch the dough together. Spread finely chopped vegetables on one half, and place the chicken leg on top of the dough so that the bone sticks out. • Fold the dough and pinch it together at the edge, pressing in the "stitches" with the end of a spoon. • Place on a plate decorated with small daisies: it will look like a fairy tale.

. . . and the gingerbread house was not made out of gingerbread but of pizza. And the three bears were eating pizza before Goldilocks came . . .

Stardust

All children know there is magic in
the night sky. • Here the gold
pepper stars, the stuffed olive
flowers, and the crispy pizza sky
are perfect for a picnic before
bedtime.

Rose Garden

Every castle has its rose garden. • To make ours, first bake a Pizza Margherita. • Then cut zigzag wedges into the tomatoes with a sharp knife until you hit the middle. Go all the way around so you can lift the halves apart. • Decorate with basil leaves and enjoy.

Some children don't care about pizza, but would rather eat their tomatoes fresh!

PIZZA
Rapunzel

Rapunzel, Rapunzel, let down your long spaghetti hair. •
This one is a real challenge to make because it takes a bit
of practice to braid spaghetti. But you'll be able to do it! •
Your reward will be happy children. With both pizza and
spaghetti on one plate, you've made two of their dream
meals come true.

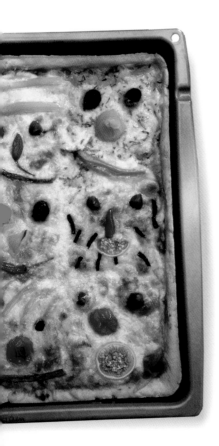

A hit for a child's party. • A whole baking sheet full of pizza dwarfs. • Original, individual, and fast. • Cover the baking sheet with dough and spread on tomato sauce and cheese. • Using the back of a knife, draw lines to divide the dough into twelve pieces. This makes it easier to place the individual faces.

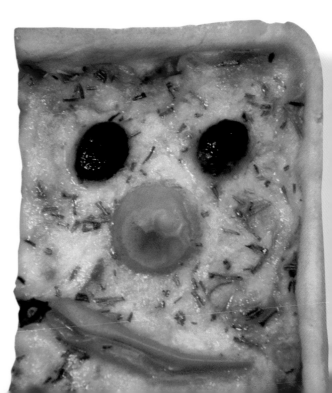

PIZZA DWARF
Stubby Beard

All he needs are capers for the eyes, a piece of pepper for the nose, seaweed strips for beard stubble, and a piece of yellow eggplant for the mouth.

PIZZA DWARF
Pepper Nose

Asparagus spears for the forehead, olives and capers for the eyes, a spicy or sweet pepper for the nose, and a bean for the mouth make this pizza dwarf healthy.

Oho!

Be surprised by a face of two capers, one cherry tomato, and a slice of yellow eggplant.

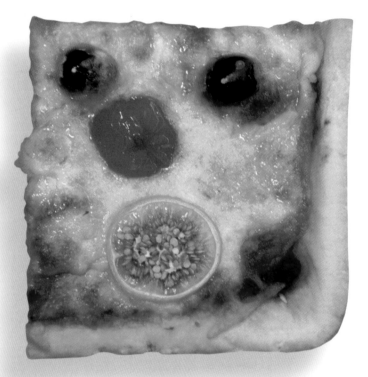

PIZZA DWARF

Square Head

Square, practical, and good to eat. What more can you ask for?

Tomato Nose

The <u>hip hairstyle</u> is made from pepper strips. The rest you already know. Have fun!

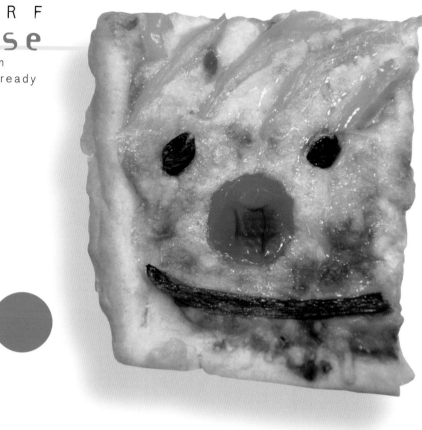

Your friends are great models for pizza faces.

93

Recipe Index

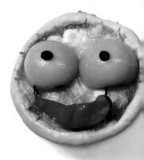

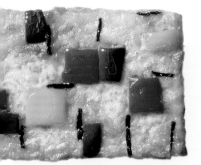

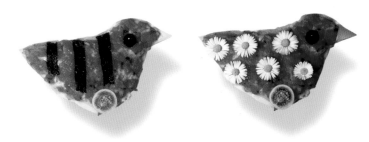

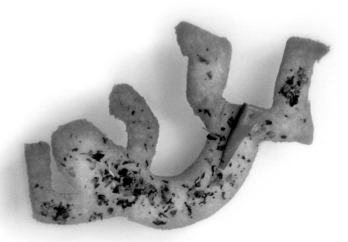

Karin Niedermeier studied <u>communication design</u> at college in Munich. She now freelances as a graphic artist. • *Her passions include <u>typography</u> and the crazy stuff of life.* • *While still a student, her first book entitled <u>emotions</u>: Cultural Communications without Words was published.* • *With* **funny foood,** *her lifestyle cookbook series for new cooks and joyful occasions, she set a new standard for cookbooks.* • *The published titles in this series are: <u>eggzentrik</u>, <u>Crazy Cats</u>, <u>sweet hearts</u>, <u>Pizza Panic</u>, and <u>funny foood</u>.* • *In her books, you can expect unique, innovative food design with a lot of wit, charm, and loving details.*